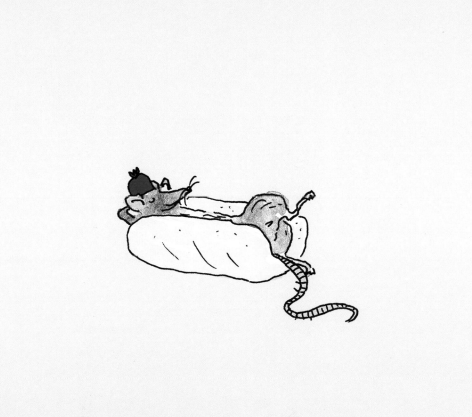

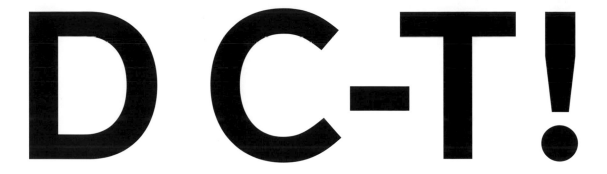

PENGUIN PRESS
New York
2018

D C-T!

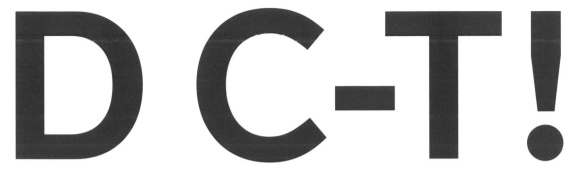

Joana Avillez and Molly Young

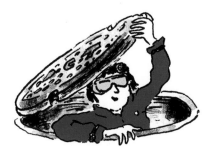

"I managed, after some worry, to solve the message, and very few things in
after life gave me as much pleasure as did the unraveling of that code."
– Harry Houdini

"New York knew how to deal."
–Henry James, *A Round of Visits*

PENGUIN PRESS

An imprint of Penguin Random House LLC
375 Hudson Street
New York, New York 10014
penguin.com

Illustrations copyright © 2018 by Joana Avillez
Text copyright © 2018 by Molly Beth Young

ISBN 9780735223196 (hardcover)

Printed in China

1 3 5 7 9 10 8 6 4 2

Designed by CHIPS

For our dads
David and Martim

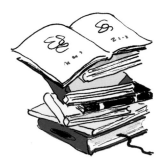

Contents

Introduction 3

Fall 8

Winter 28

Spring 48

Summer 70

Key 97

How to describe
this book?

Are these pictograms? Rebuses? Logograms? Verbographs? Puzzles? Visual riddles? Or are they something else entirely? We'll go with "something else" for now.

In 1968, artist and author William Steig—perhaps best known these days for inventing the character Shrek—published a book called *CDB!* Composed of illustrations in a loose hand paired with encrypted captions, *CDB!* was "something else." Readers of every age were challenged to decode each scene. Part mystery, part story, part Duchampian game.

Skip ahead to the early 90s, when we were children on opposite coasts. Our respective fathers each gave us a copy of *CDB!* The fathers were not in cahoots; in fact, the fathers lived 3,000 miles from each other and had never met. They simply appreciated the book's ingenuity and thought

their daughters might appreciate it too. The fathers were correct. Two decades later, the daughters (us) met. Discussions were had. Books were recommended. Friendship occurred. Ideas percolated.

"Wouldn't it be fun to take the puzzle form that William Steig invented and create a whole new version for the present day?" we thought.

"Yes," we also thought.

"And wouldn't it be terrific to set the new book in New York, our home, the land of audacious rats, sophisticated babies, superior lox and heroic pedestrians?"

"Yes," we autoreplied.

"And when shall we start this process?"

"We should start this process now, after a snack."

And here we are. *D C-T!* is a book of puzzles in the key of New York. The illustrations are the illustrations. The letters are the captions. Decode the captions by verbalizing them out loud. If that doesn't work, seek the advice of a child.*

* If no children are available, there is an answer key in the back.

S A P-N

"It's a paean"

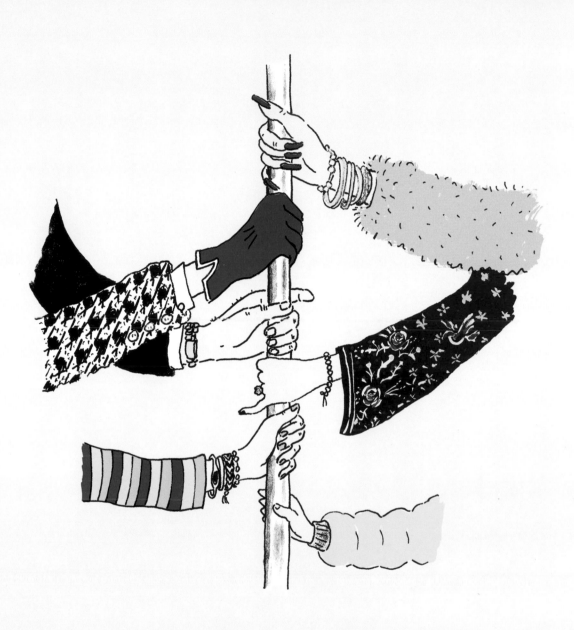

D C-T!

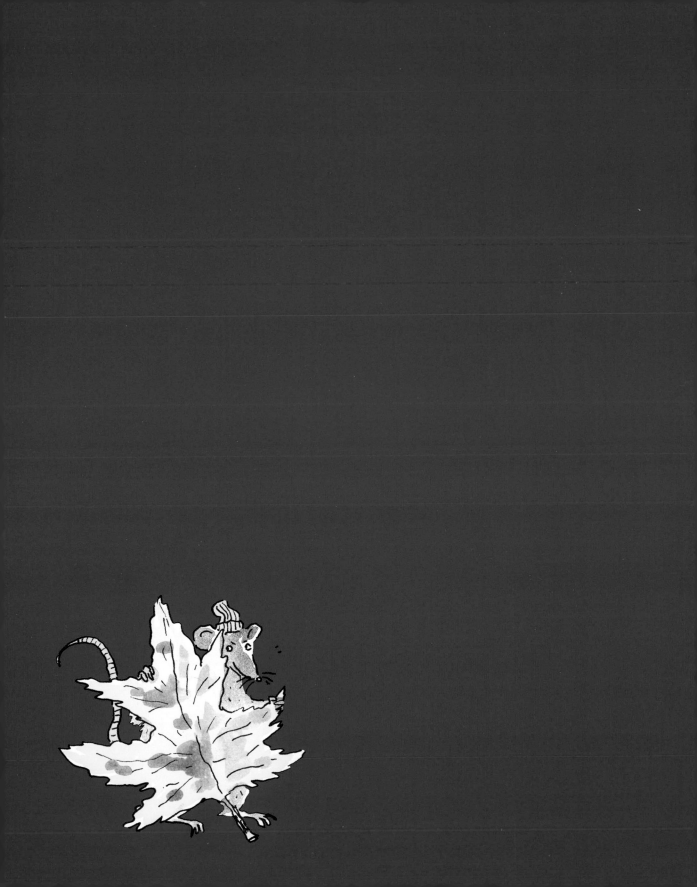

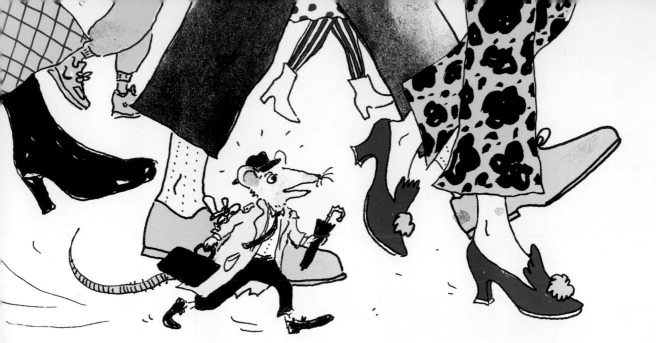

I M L-8

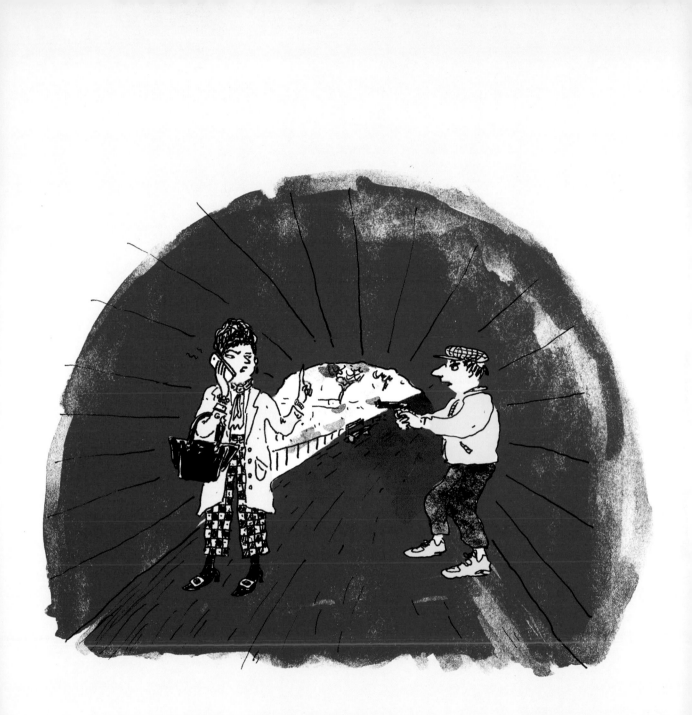

I M B-Z

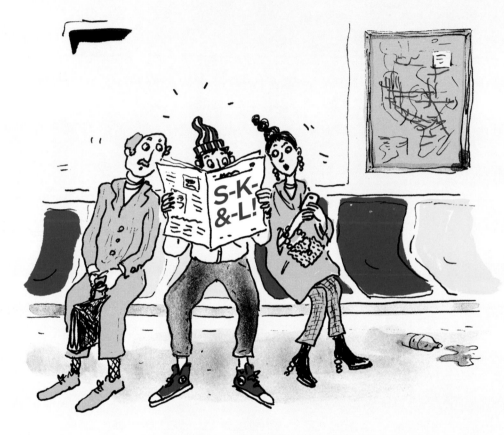

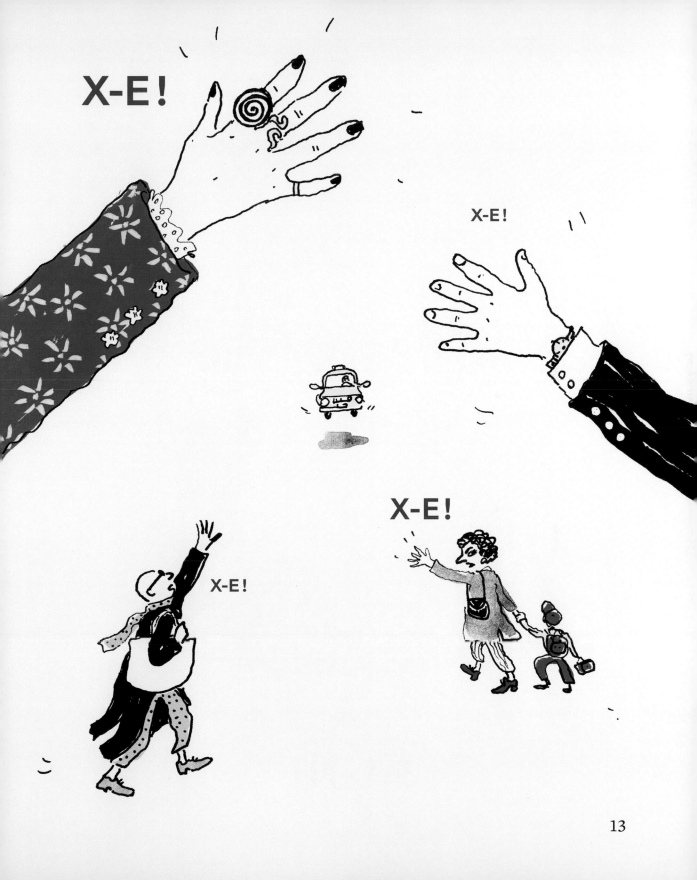

13

3-L-N!

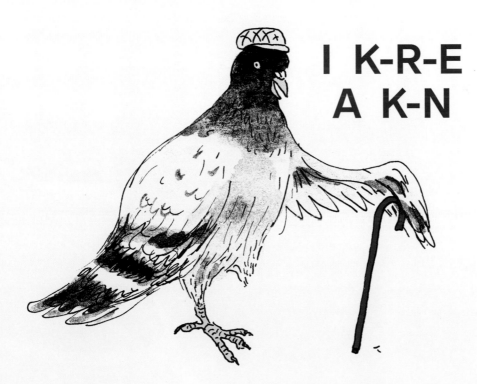

I K-R-E
A K-N

15

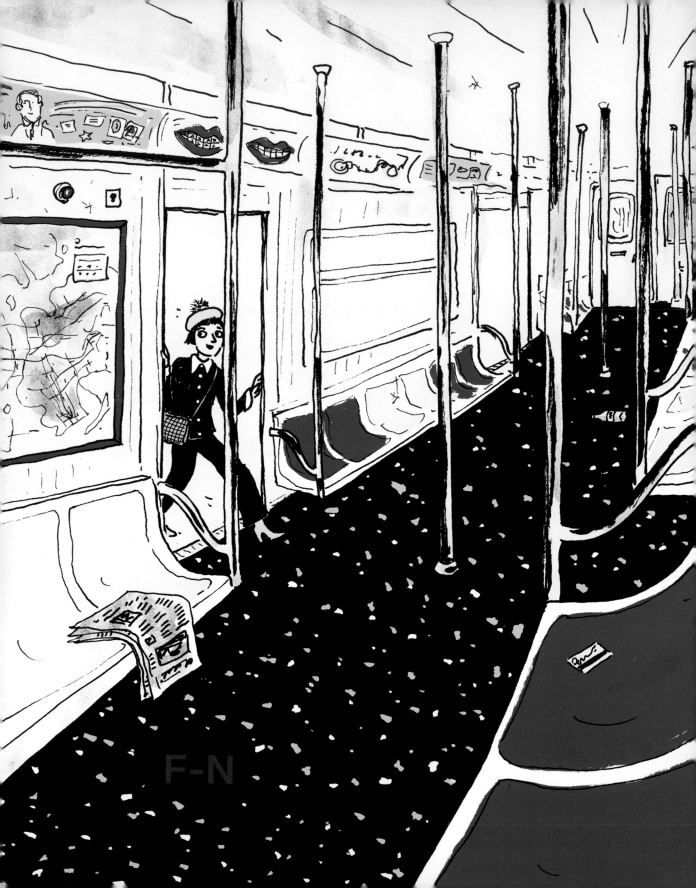

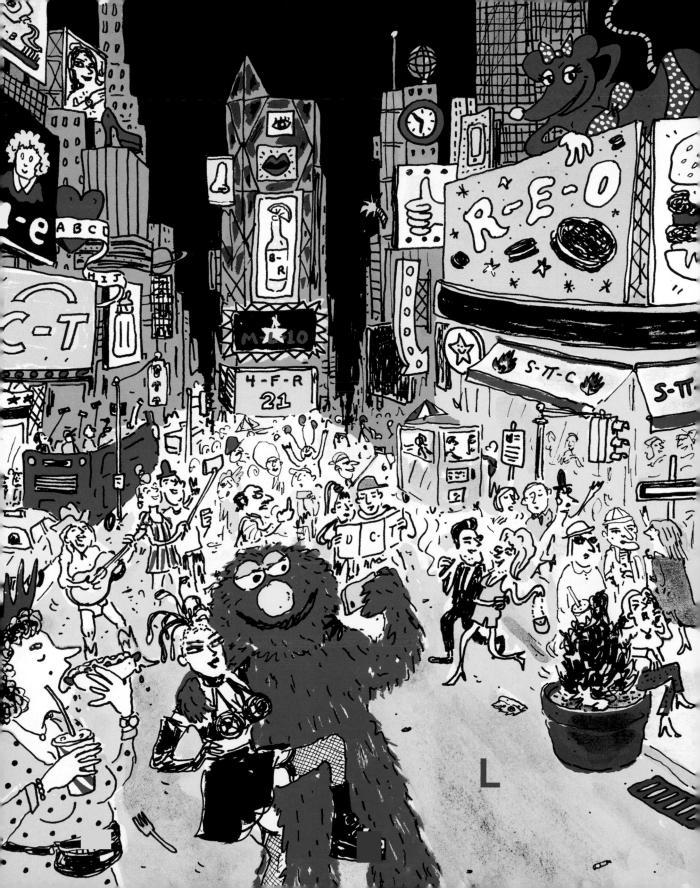

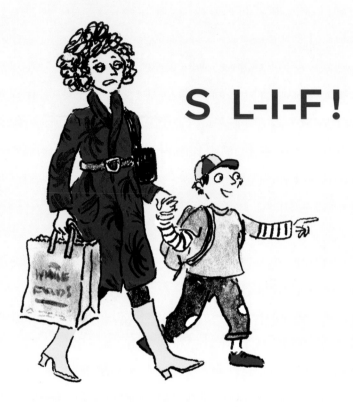

S L-I-F!

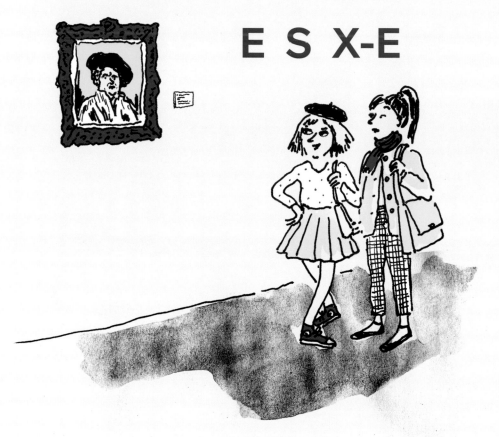

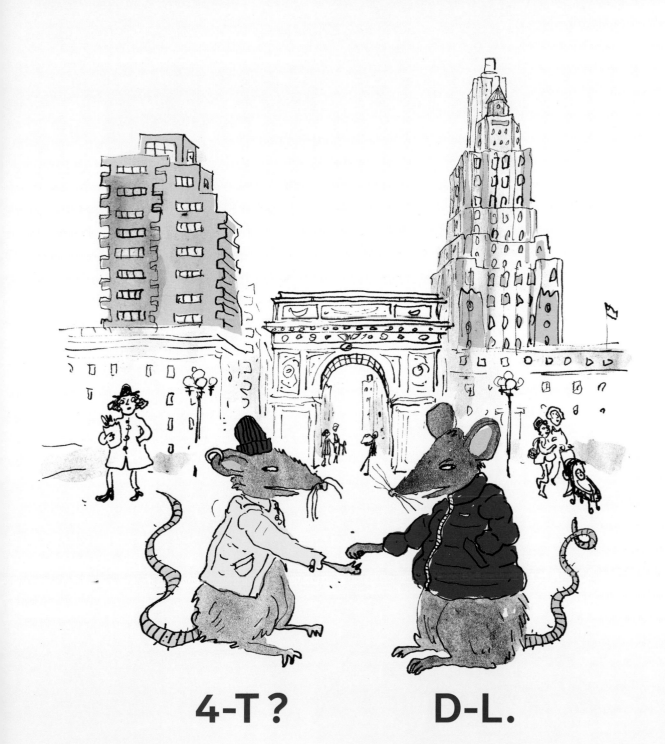

4-T? D-L.

21

B-L-E

C-D

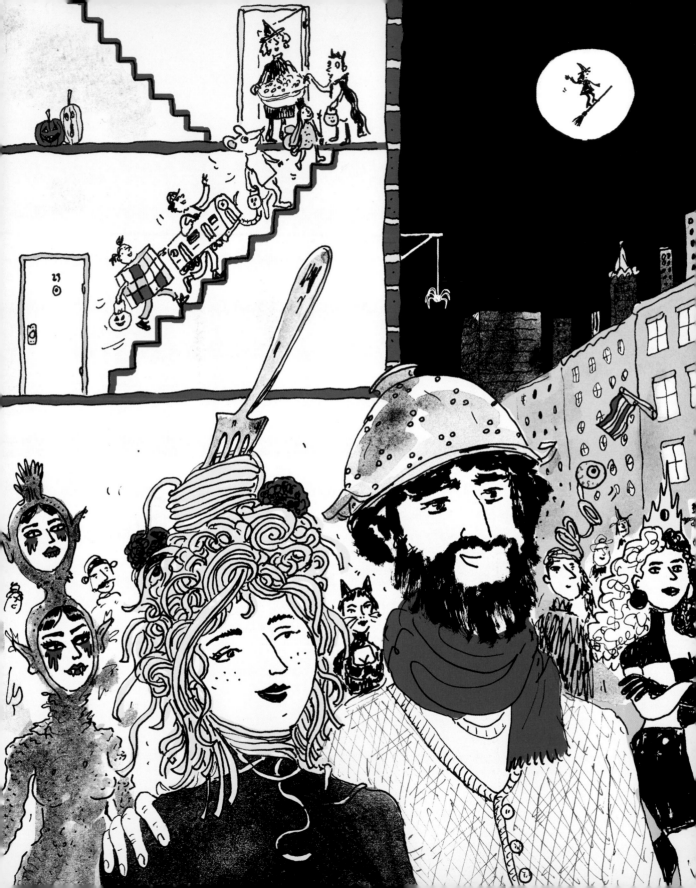

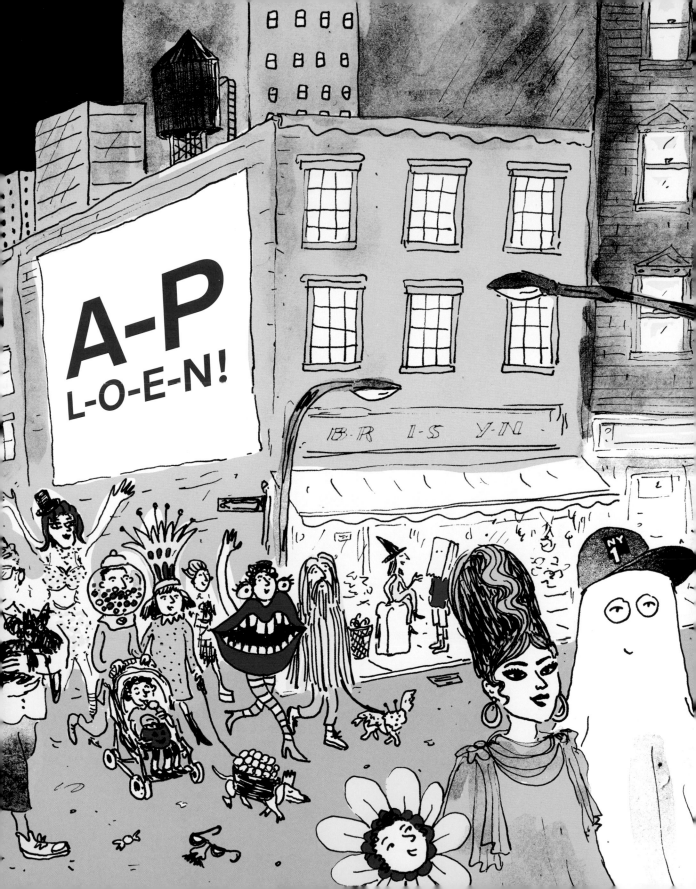

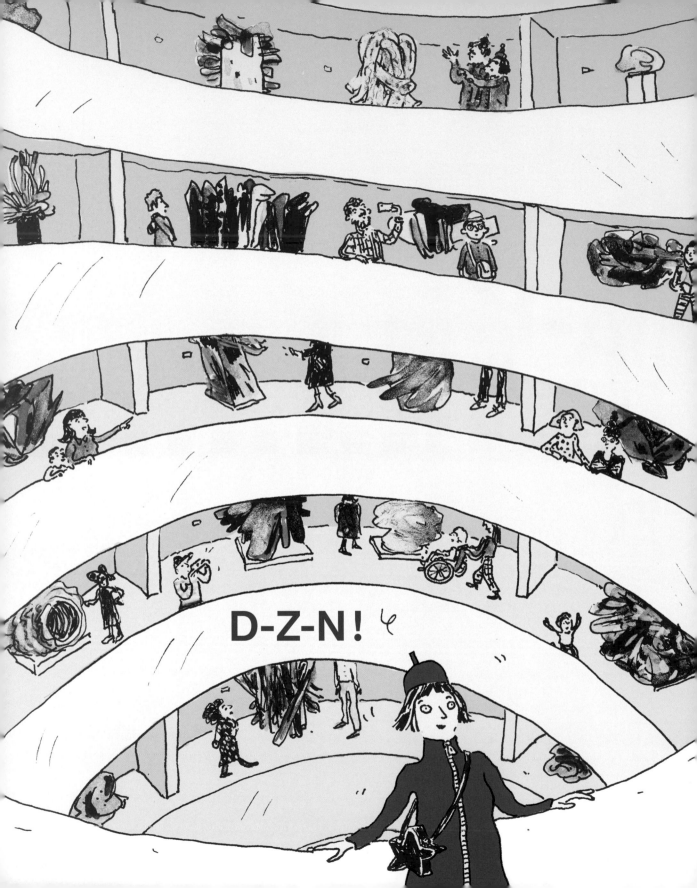

O-D-S

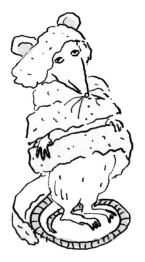

Winter

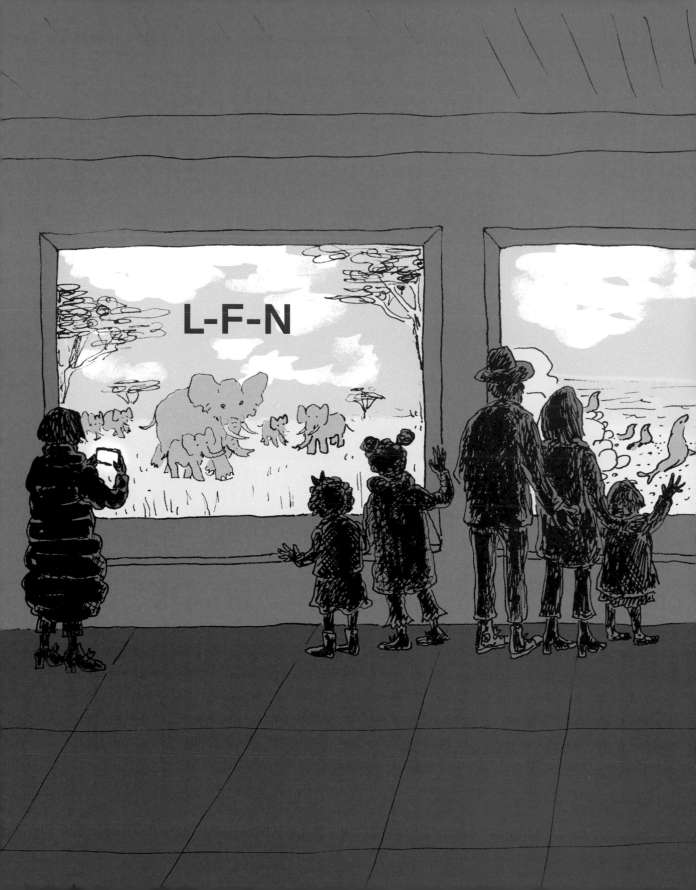

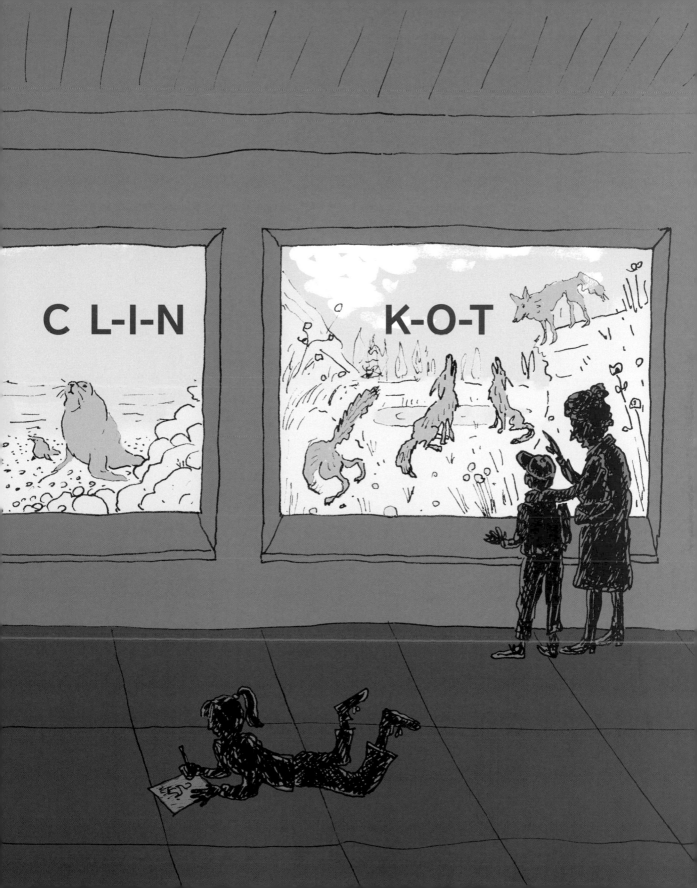

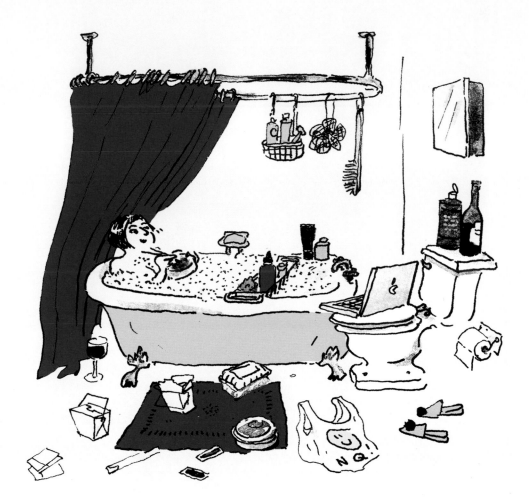

Y-N &-I-N

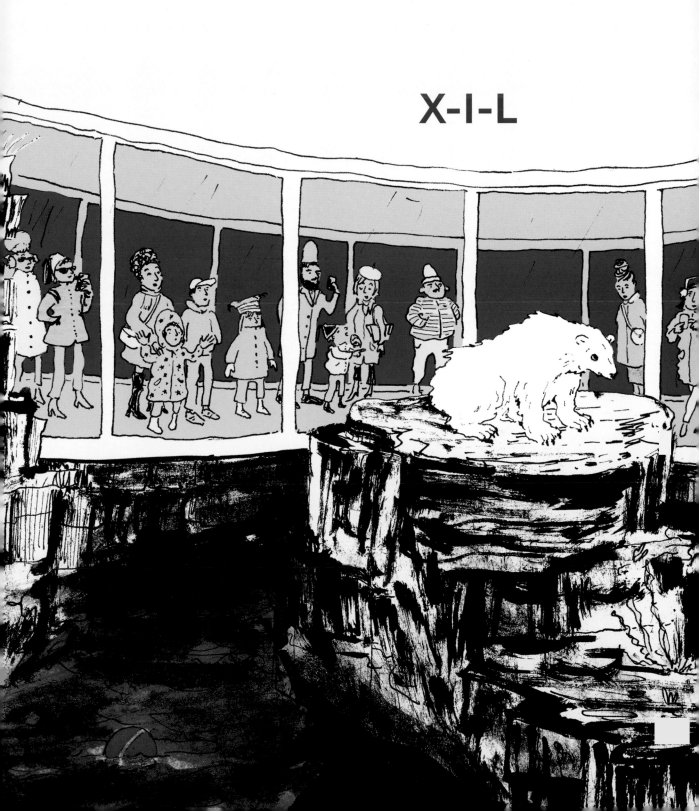

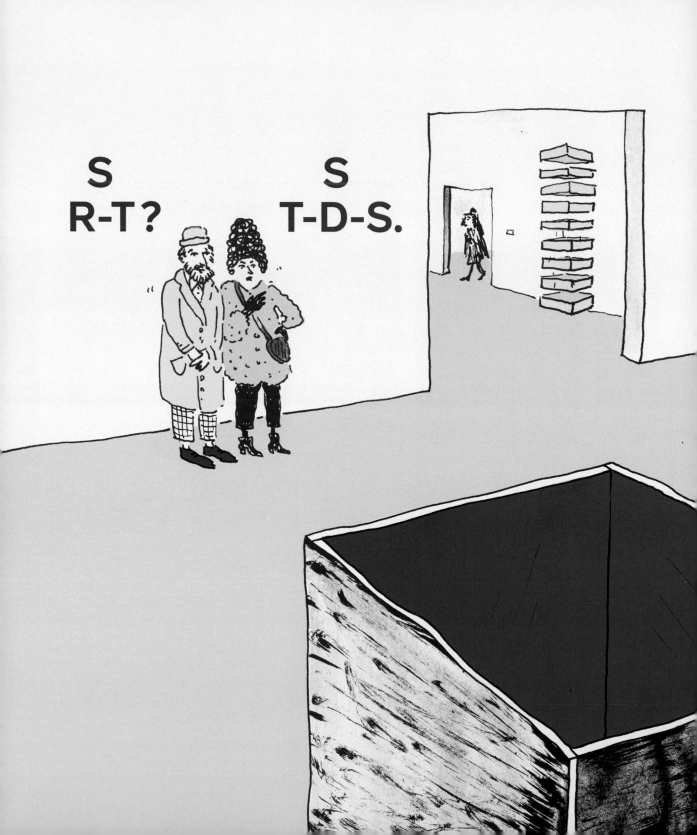

I M N A J-M

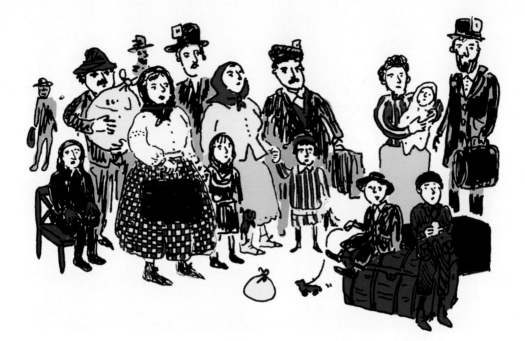

L-S I-L-N

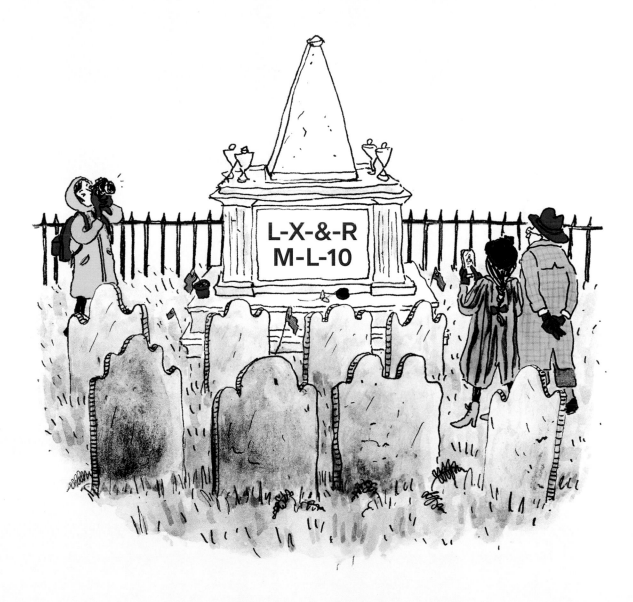

C-Q-R-T

K-L S L-T

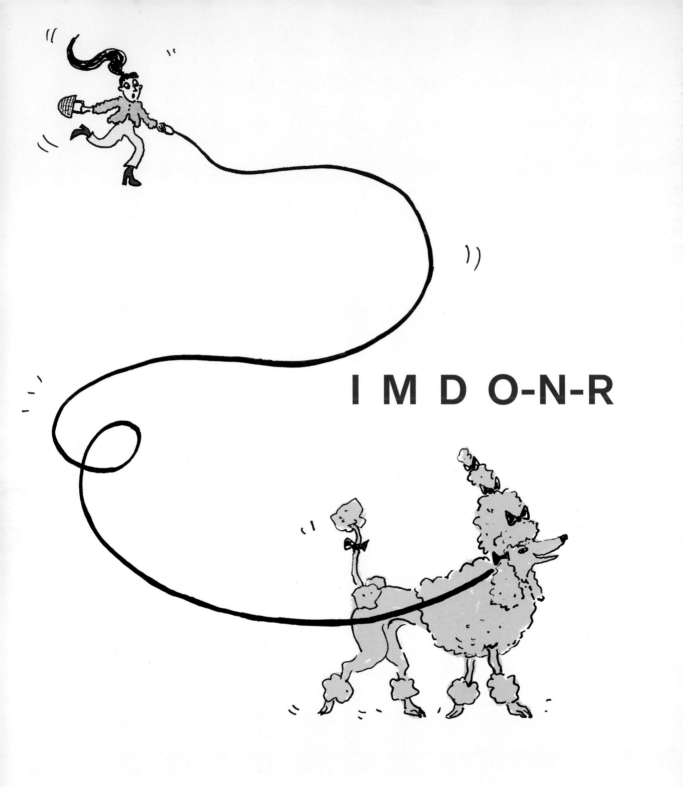

I M D O-N-R

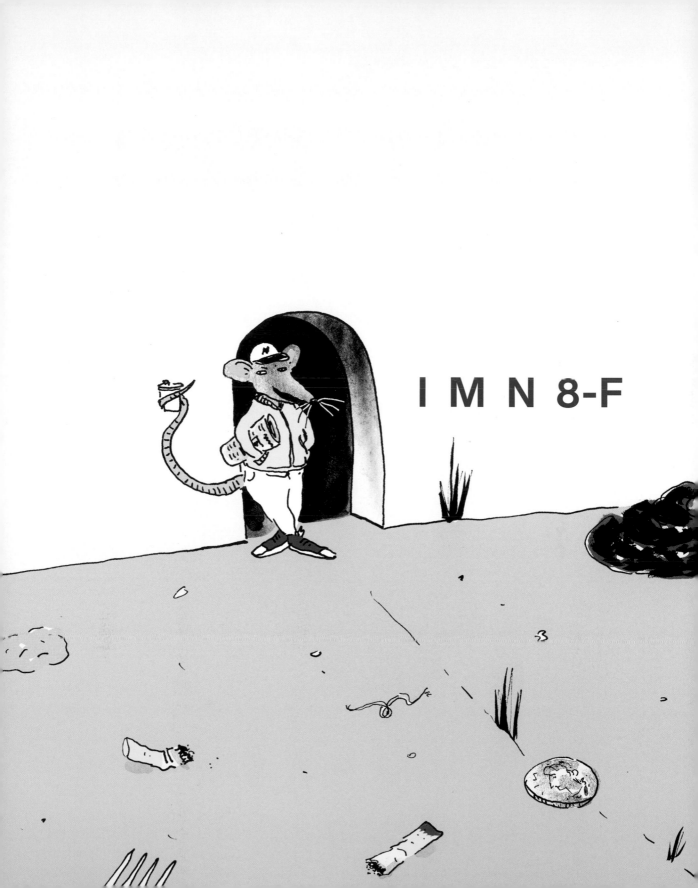

I M N 8-F

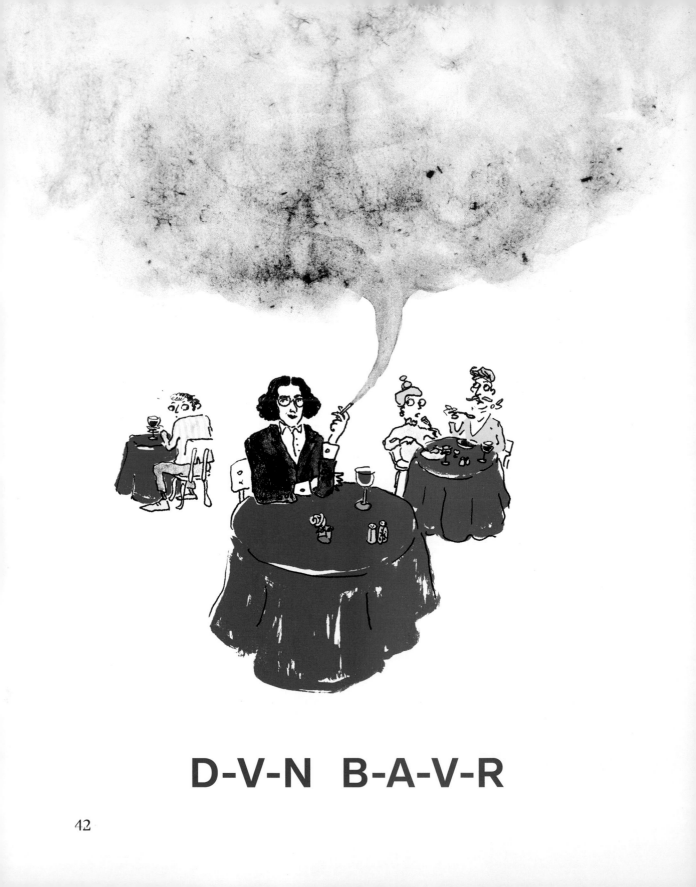

D-V-N B-A-V-R

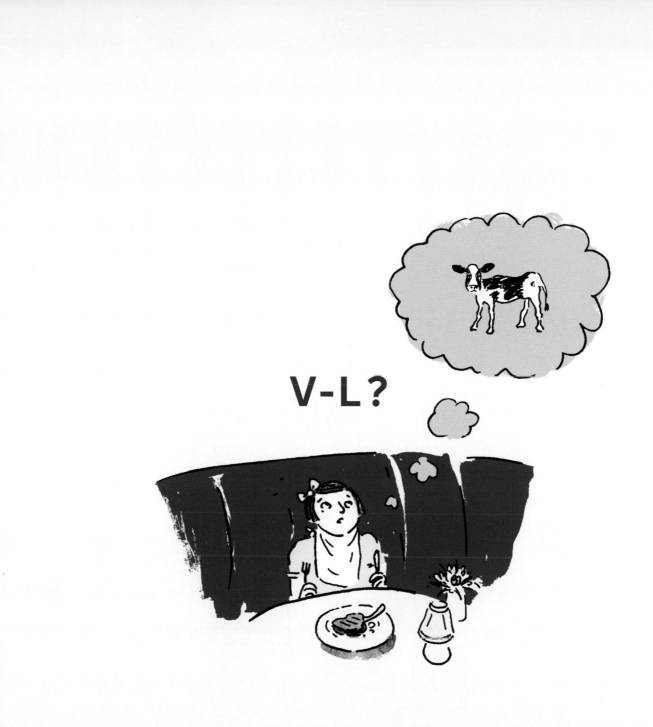

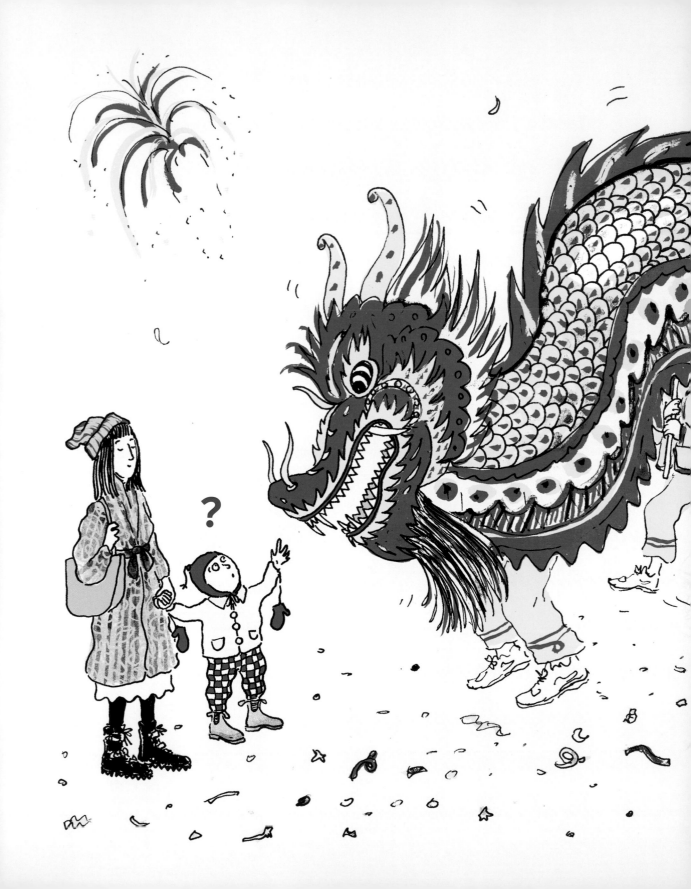

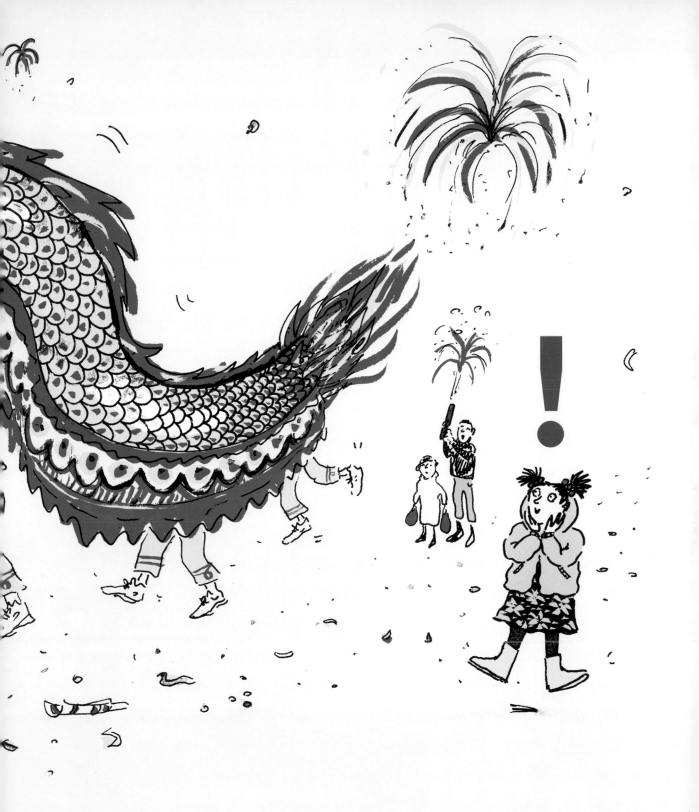

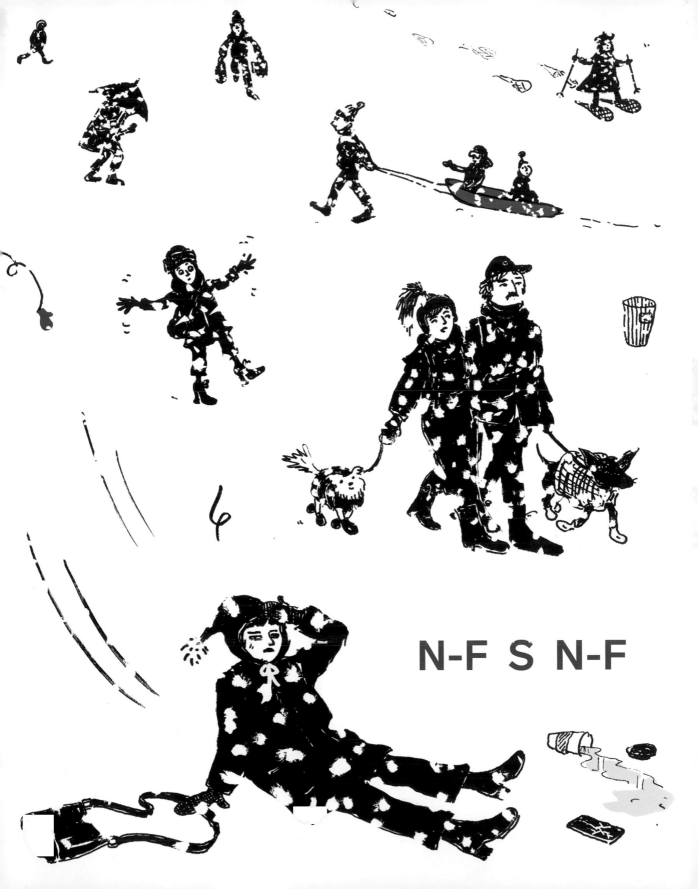

N-F S N-F

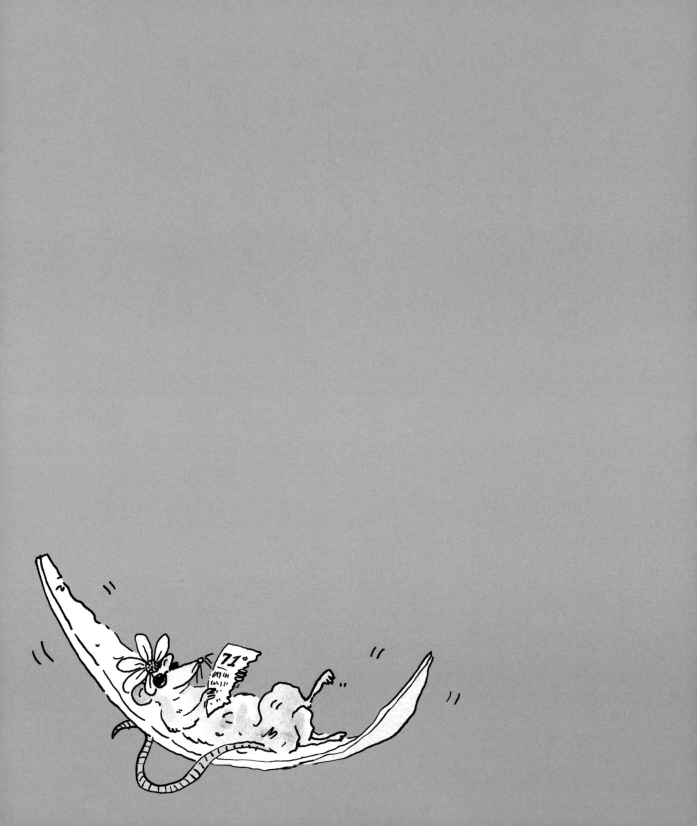

L-R-G

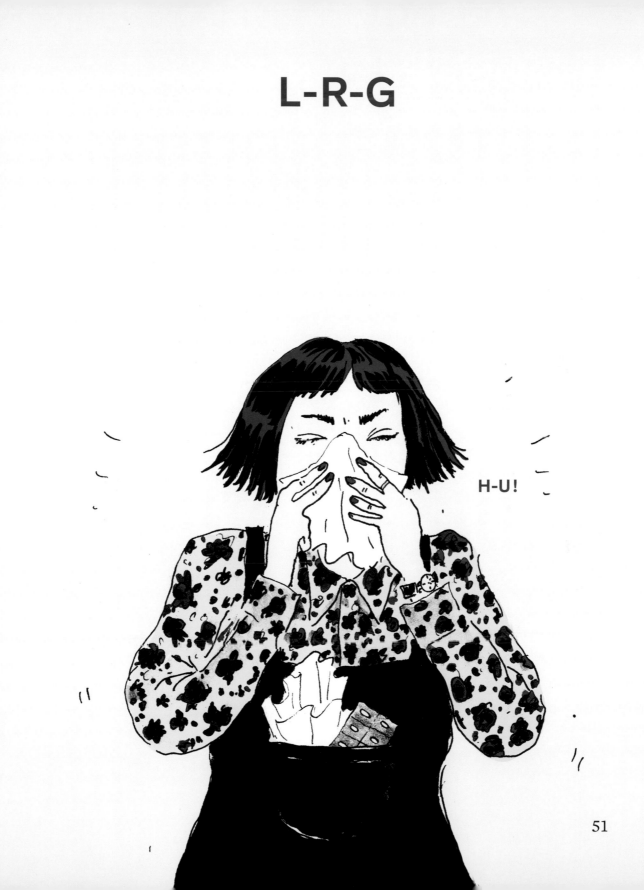

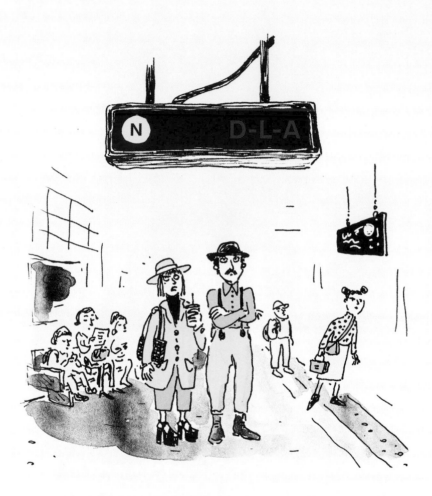

S M-R-L

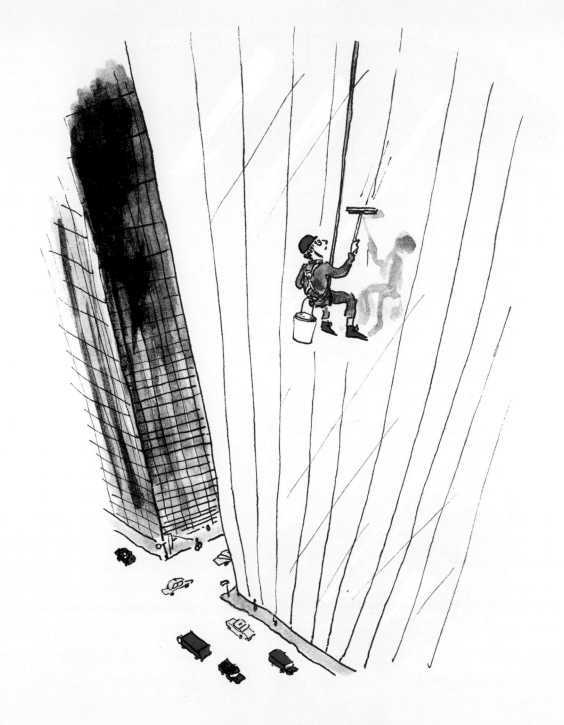

S-K-R-E

N-E I-D-S?

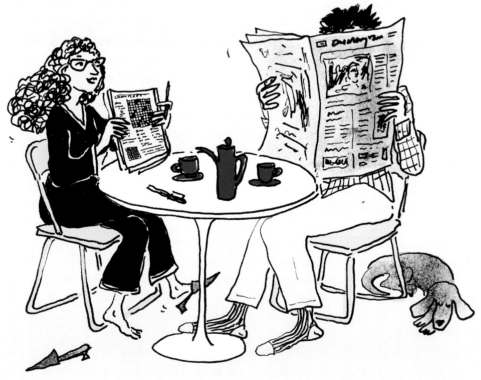

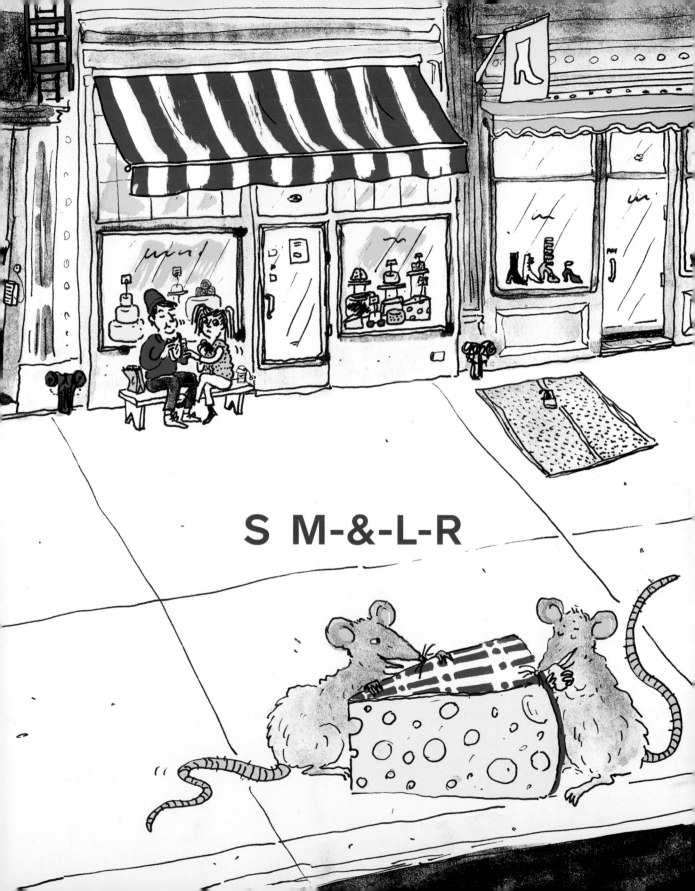

S Q! S E-T-B-T

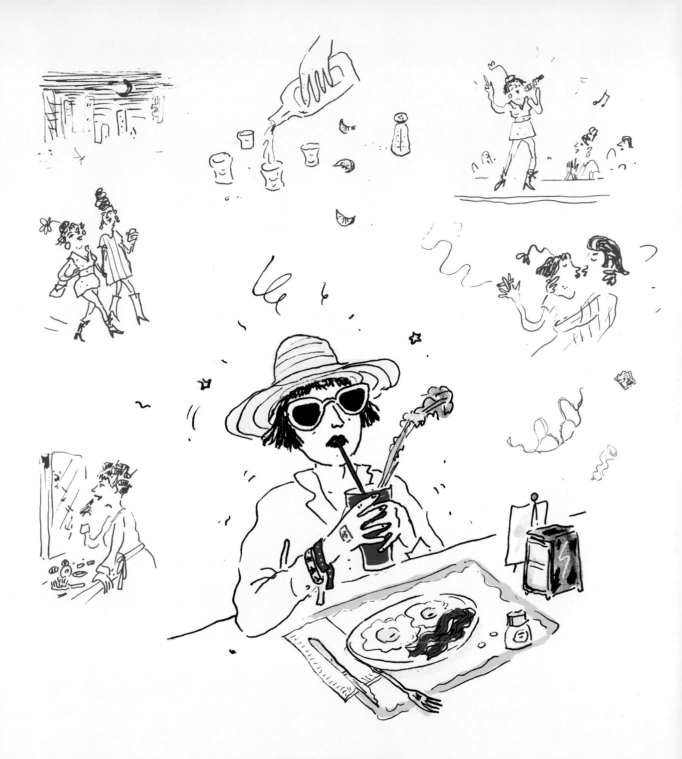

D Q-R

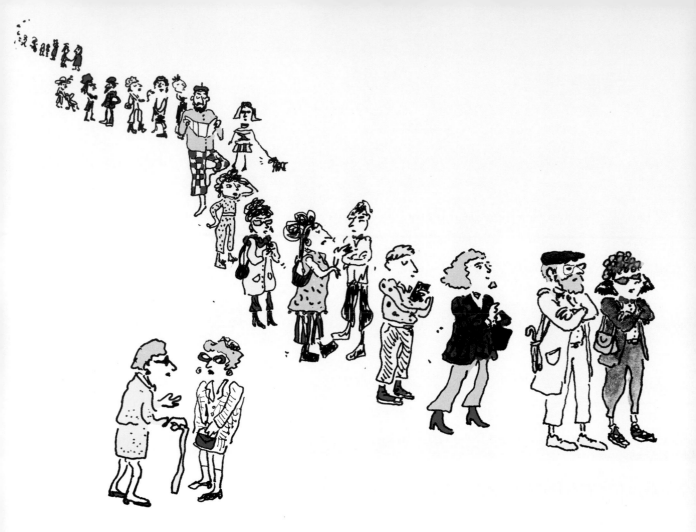

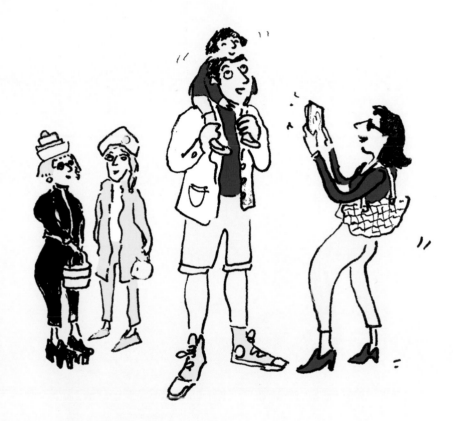

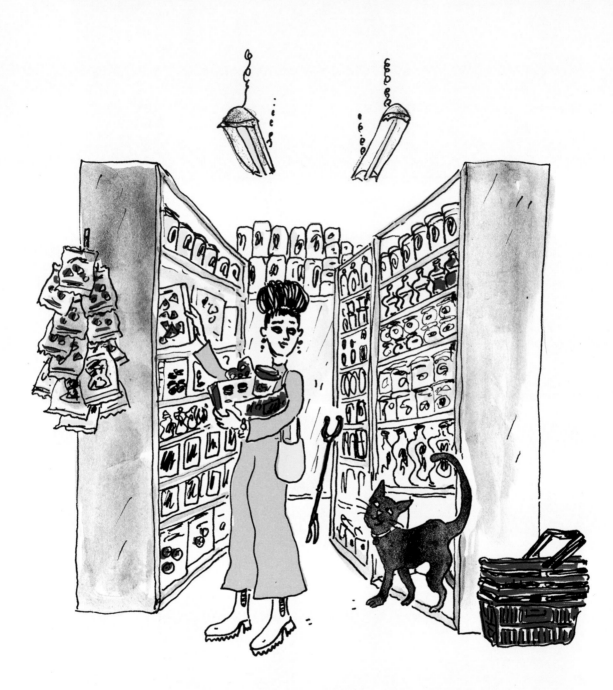

R U I?

N-I-L-8 M!

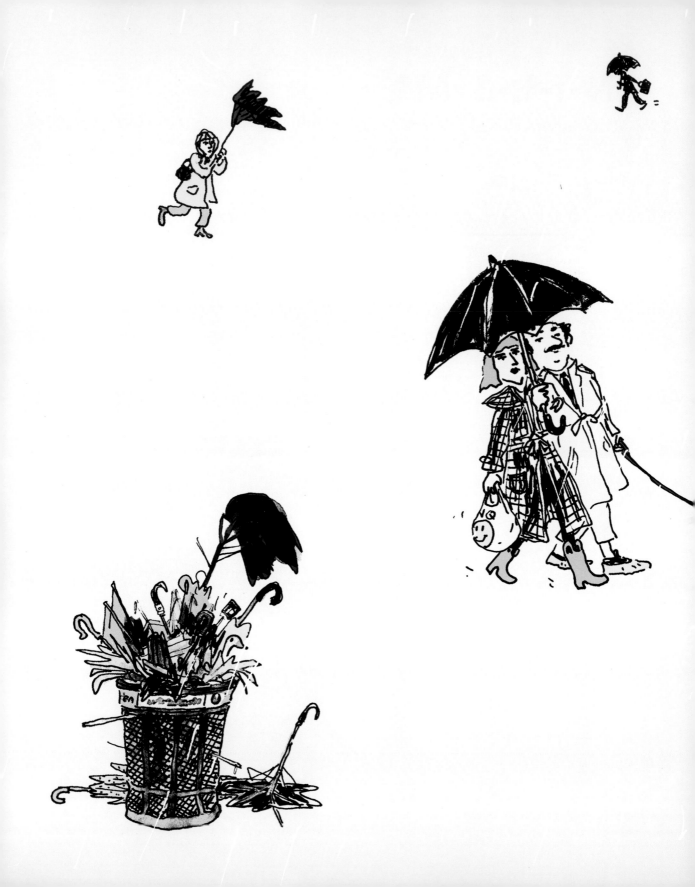

X-S-R-E

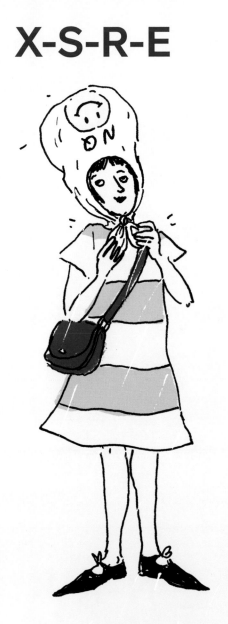

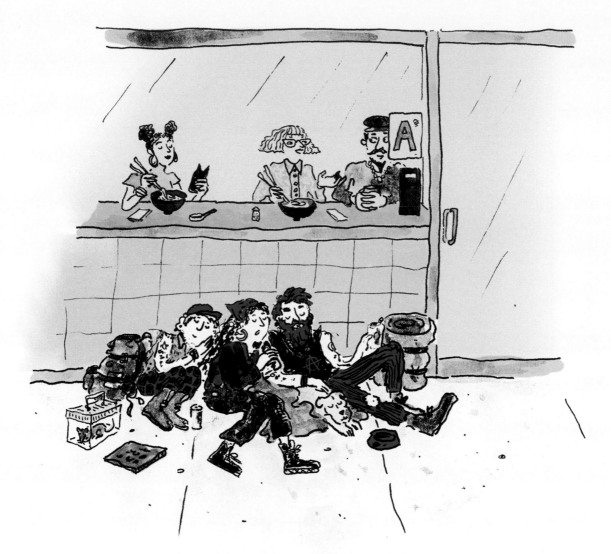

N-R-K

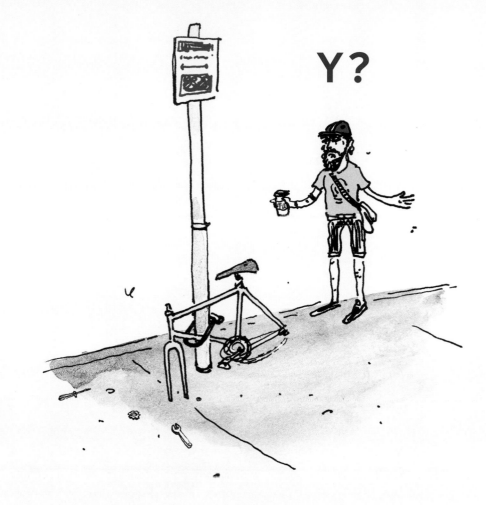

Summer

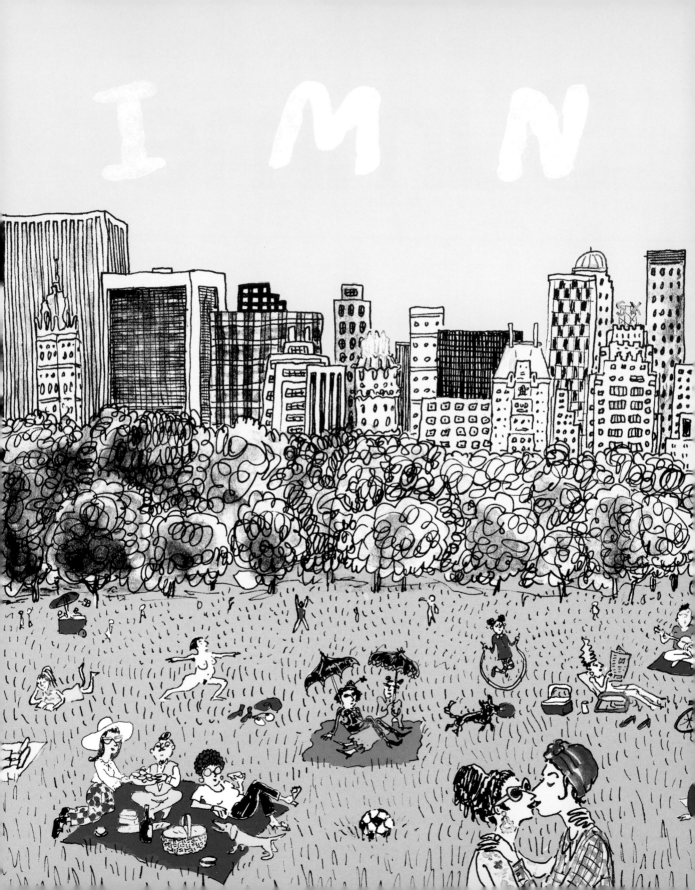

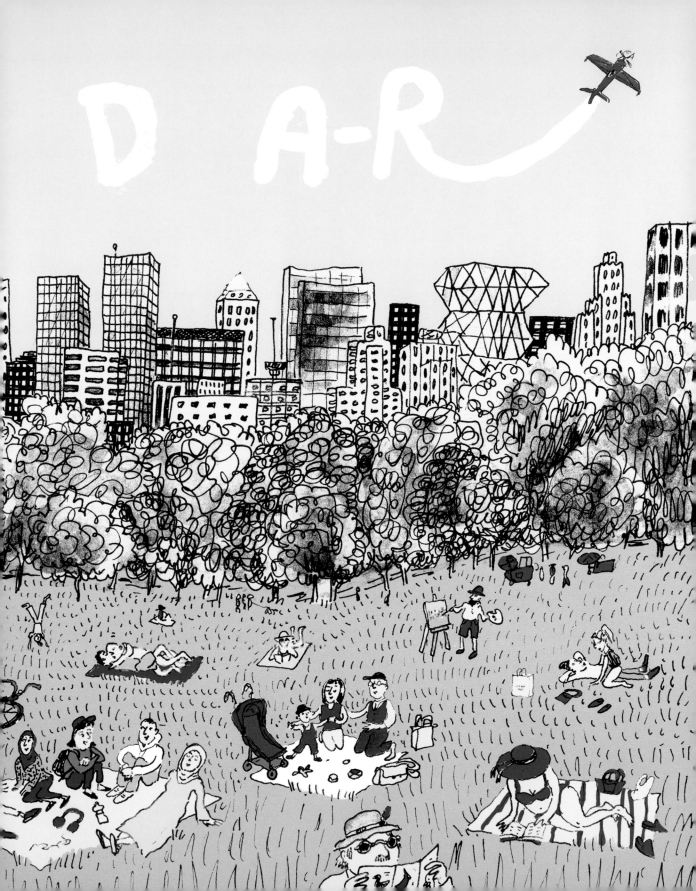

I M D Y-F I M D Y-F

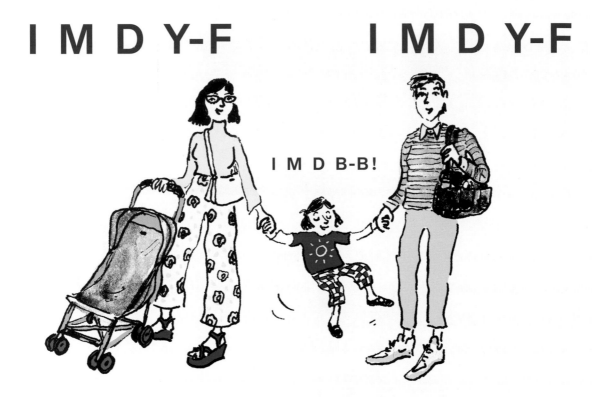

I M D B-B!

&-R-S N K-S F-I-R

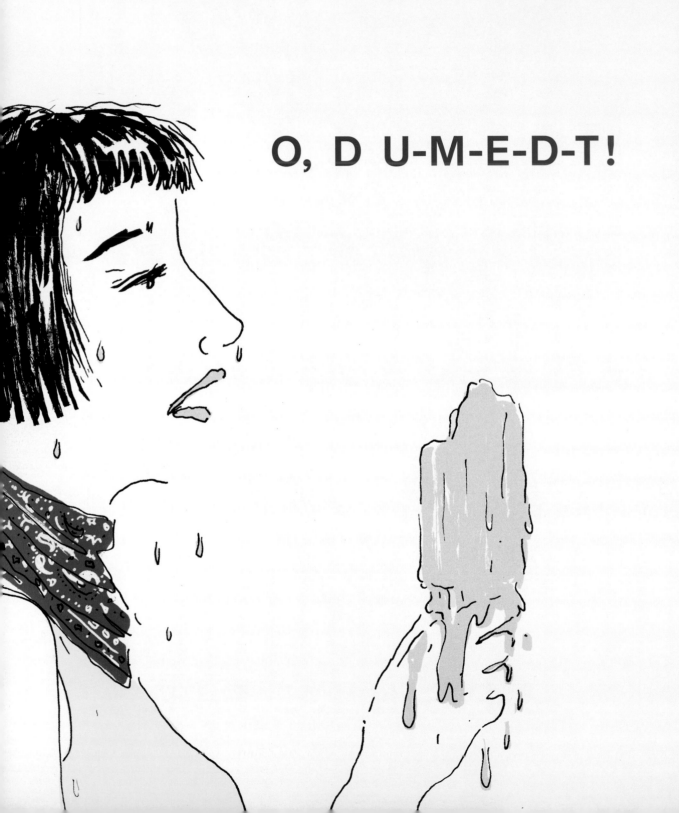

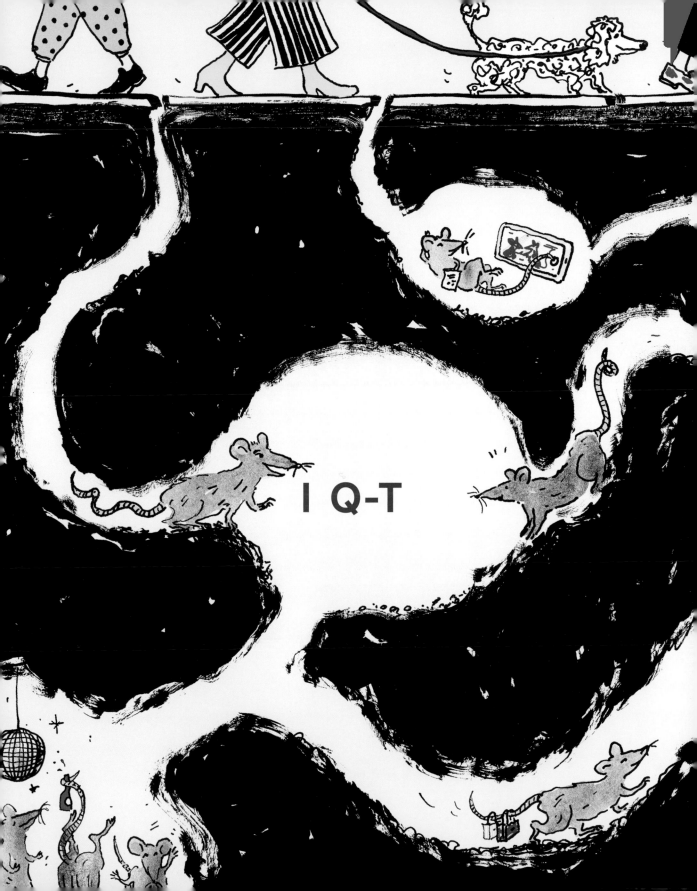

I Q-T

I-G-N

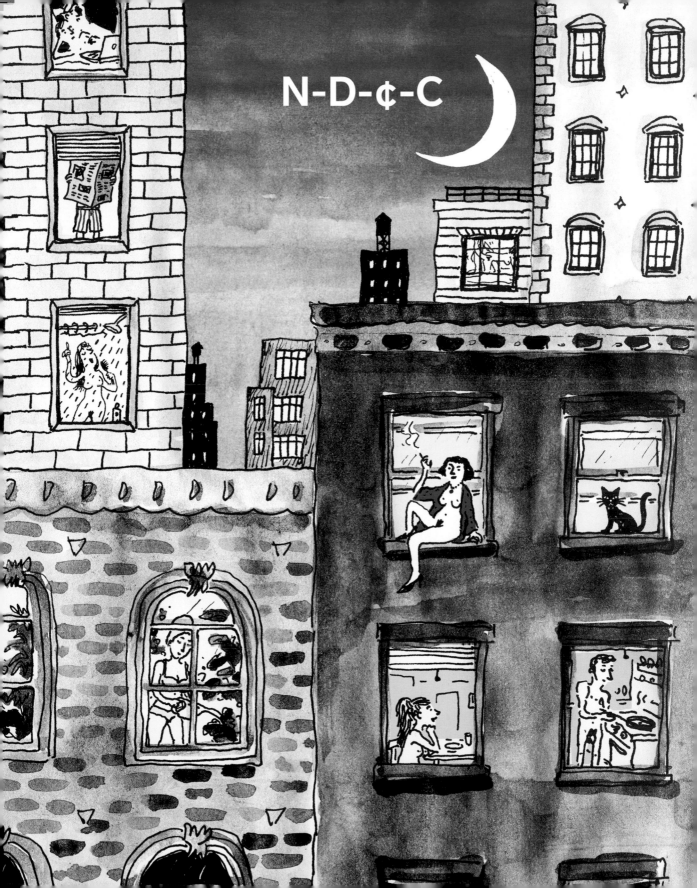

Y-L-I-F

T-P-K-L

S I-S T

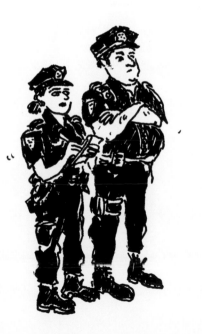

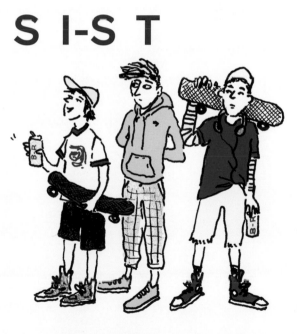

S N-K-N-E

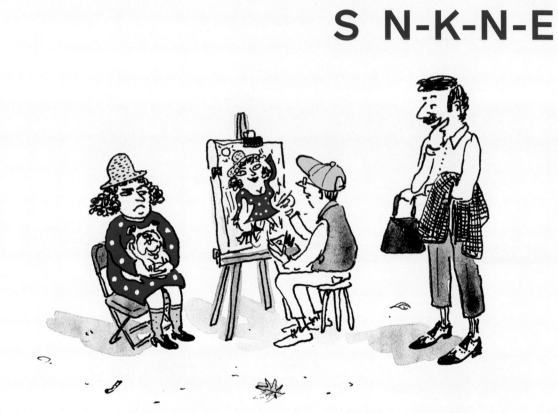

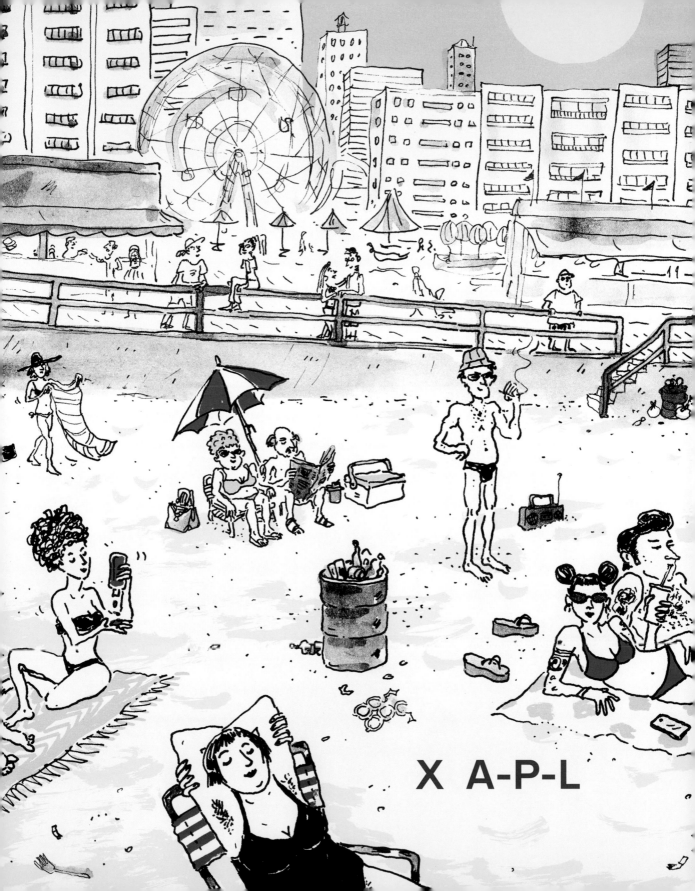

G-M

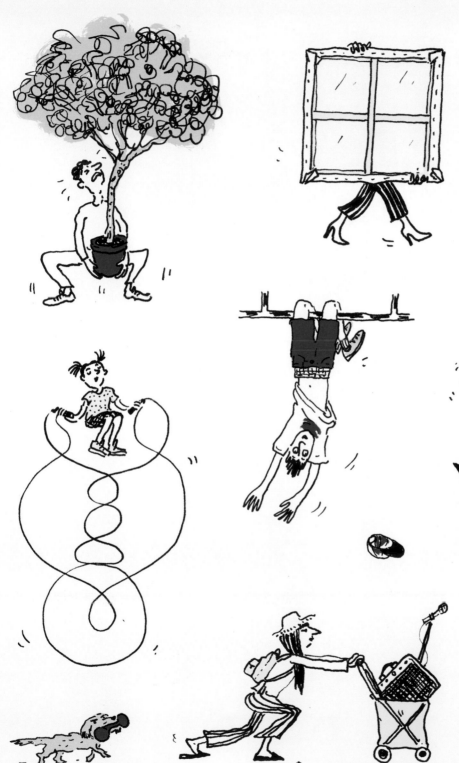
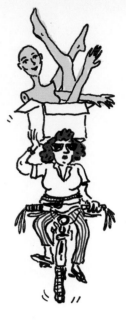
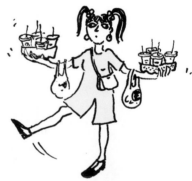
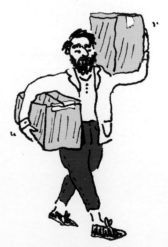

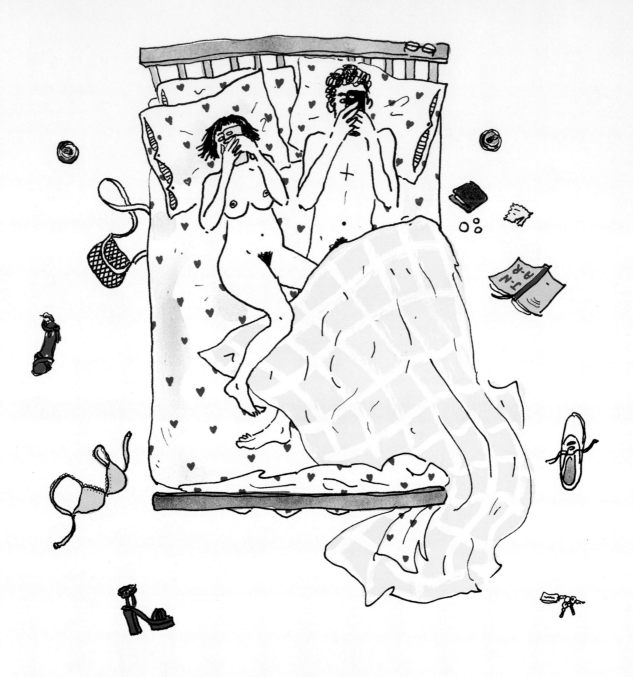

X & D C-T

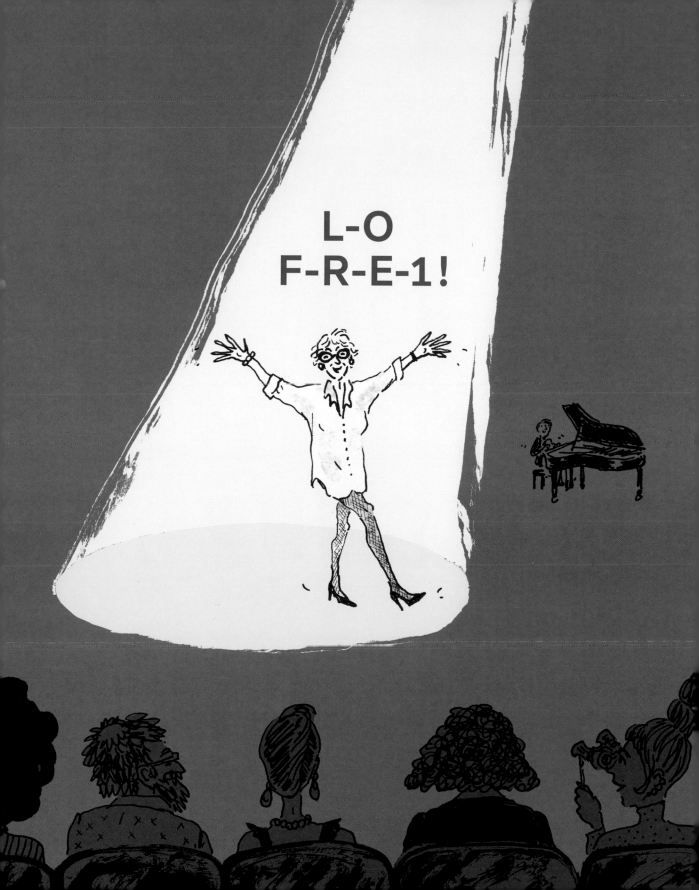

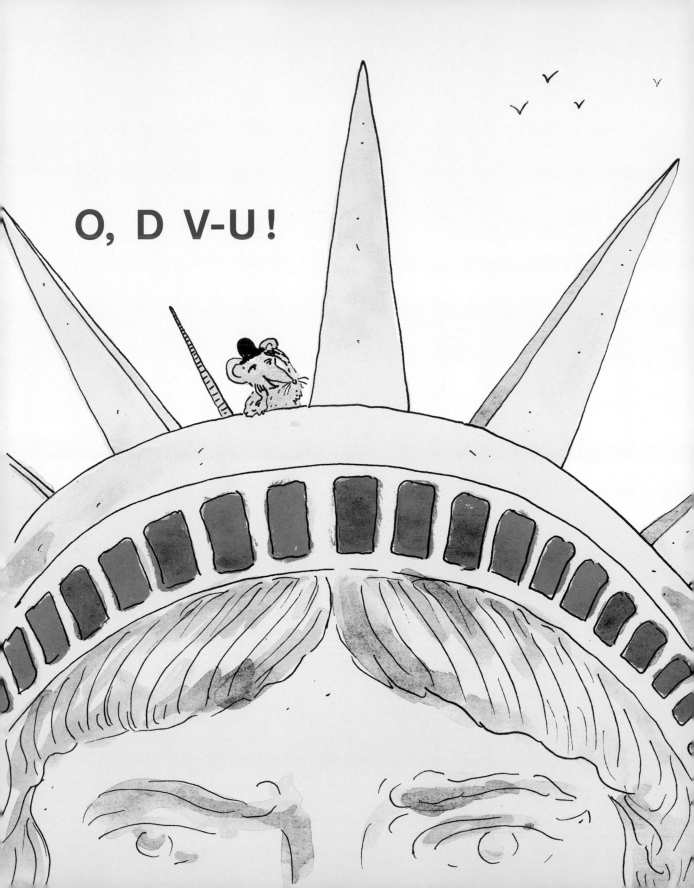

P

R-A!

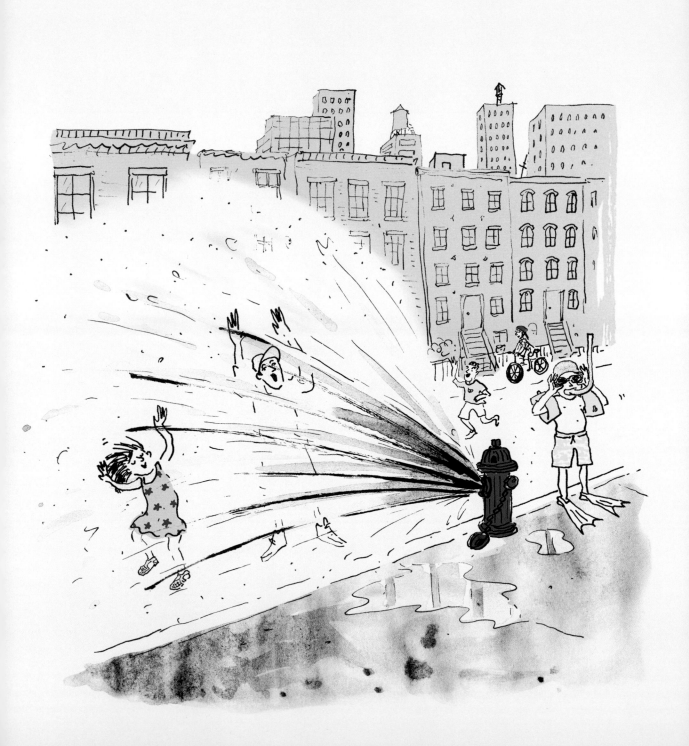

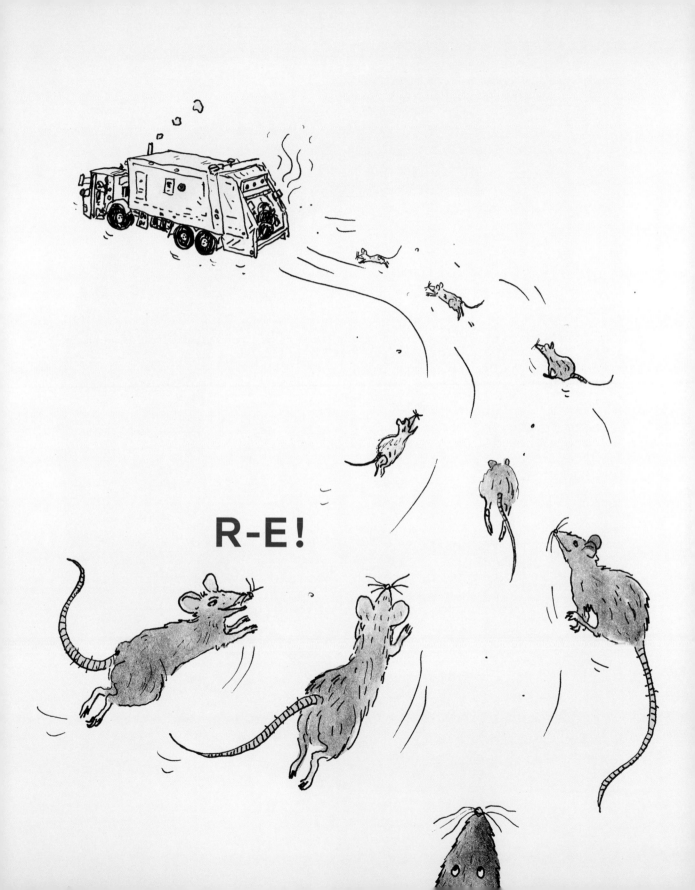

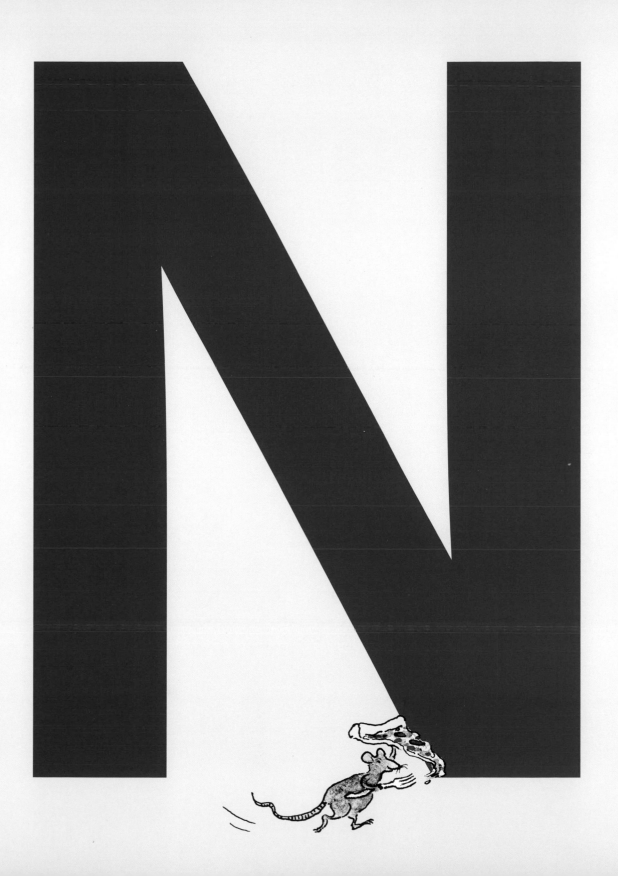

Key

Fall

10 I M L-8 *I am late*

11 I M B-Z *I am busy*

12 S-K-&-L ! *Scandal!*

13 X-E ! *Taxi!*

14 3-L-N ! *Thrilling!*

15 I K-R-E A K-N *I carry a cane*

16 F-N *Heaven*

17 L *Hell*

18 S L-I-F ! *It's alive!*

20 E S X-E *He is sexy*

21 4-T ? D-L. *"Forty?" "Deal."*

22 B-L-E *Bialy*

23 C-D *Seedy*

25 A-P L-O-E-N ! *Happy Halloween!*

26 D-Z-N ! *Dizzying!*

27 O-D-S *Odious*

Winter

30 L-F-N *Elephant*

31 C L-I-N *Sea lion*

 K-O-T *Coyote*

32 Y-N &-I-N *Wine and dine*

33 X-I-L *Exile*

34 S R-T ? S T-D-S.
 "It's arty?" "It's tedious"
35 I M N A J-M *I am in a jam*
36 L-S I-L-N *Ellis Island*
37 L-X-&-R M-L-10
 Alexander Hamilton
38 C-Q-R-T *Security*
39 K-L S L-T *Kale is healthy*
40 I M D O-N-R *I am the owner*
41 I M N 8-F *I am a native*
42 D-V-N B-A-V-R
 Deviant behavior
43 V-L? *Veal?*
47 N-F S N-F *Enough is enough*

Spring
51 L-R-G *Allergy*
52 S M-R-L *It's immoral*
53 S-K-R-E *Scary*
54 N-E I-D-S ? *Any ideas?*
55 S M-&-L-R *It's Emmentaler*
58 S Q! S E-T-B-T
 "It's cute!" "It's itty-bitty"
59 D Q-R *The cure*
63 Q *Queue*
64 R U I ? *Are you high?*
65 N-I-L-8 M ! *Annihilate him!*
67 X-S-R-E *Accessory*
68 N-R-K *Anarchy*
69 Y? *Why?*

Summer
72–73 I M N D A-R *I am in the air*
74 I M D Y-F I M D Y-F
 I M D B-B! *"I am the wife"*
 "I am the wife" "I am the baby!"
75 &-R-S N K-S F-I-R
 Dangerous in case of fire
76 O, D U-M-E-D-T!
 Oh, the humidity!
77 I Q-T *Hi cutie*
78 I-G-N *Hygiene*
79 N-D-¢-C *Indecency*
81 Y-L-I-F *Wildlife*
82 T-P-K-L *Typical*
83 S I-S T *It's iced tea*
84 S N-K-N-E *It's uncanny*
85 X A-P-L *Sex appeal*
87 G-M *Gym*
88 X & D C-T *Sex and the city*
89 L-O F-R-E-1 ! *Hello everyone!*
90 O, D V-U ! *Oh, the view!*
91 P *Pee*
92 R-A ! *Hooray!*
93 R-E ! *Hurry!*
94–95 D N *The end*

A note on the type

Headlines and puzzles are set in Lab Grotesque, a typeface designed by Göran Söderström in 2015 and licensed by the Letters from Sweden foundry. It is inspired by turn-of-the-twentieth-century sans serifs such as Akzidenz-Grotesk, which was also the basis for the now-ubiquitous Helvetica in 1957.

Admired for its readability and simplicity, Akzidenz was once sold as "Standard" in the United States, and in 1966, under that moniker, it was specified as the typeface to be used on all signage in the New York City subway system. (Signs made in recent decades use Helvetica.) William Steig's *CDB!* was originally set in Monotype Grotesque, another typeface of the same ilk designed in 1926.

All other text is set in Freight Text, a serif typeface designed in 2005 by Joshua Darden of Darden Studio, a New York City–based type foundry.

About the authors

Joana Avillez is an illustrator who grew up in the fish market in New York City. Her illustrations and writing have appeared in *The New Yorker*, *The New York Times*, *New York Magazine*, and many other publications without "New York" in the title.

Molly Young is a writer and creative director living in New York. She contributes writing and crossword puzzles to *The New York Times*.

N-Q

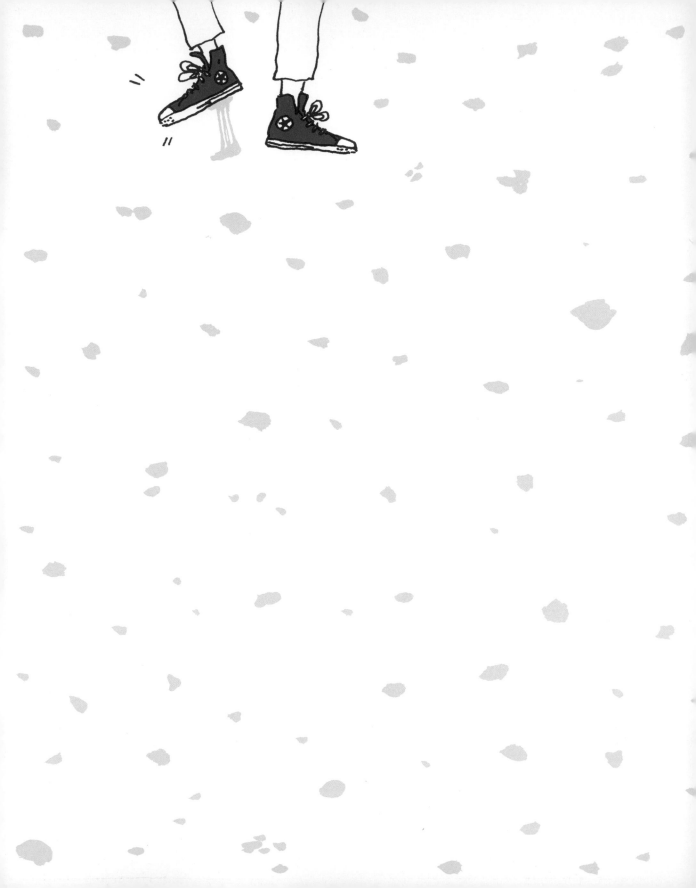